BUSH Photo Oops

Conceived and edited by Hal Buell
Captions by Sean and Chris Kelly

Black Dog & Leventhal

Paperbacks

Library of Congress Cataloging-in-Publication Data on file
at the offices of Black Dog & Leventhal.

ISBN: 1-57912-372-4

Design by Filip Zawodnik

Manufactured in the United States

j i h g f e d c b

Published by
Black Dog & Leventhal Publishers Inc.
151 West 19th Street
New York, NY 10011

Distributed by
Workman Publishing Company
708 Broadway
New York, NY 10003

Politicians love the Photo Op, which is Washington-speak for Photo Opportunity. Their affection comes from the belief that the photo op photo will make them look like world statesmen, regular guys, lovers of children and animals, or any other characterization they conceive.

Sometimes it works like that, but in the wink of a camera's shutter a Photo Op can go awry and become a Photo Oops. Consider Nelson Rockefeller giving the

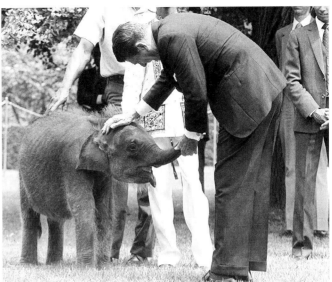

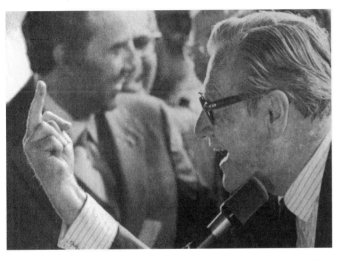

press the bird, or more recently, Michael Dukakis riding in an Army tank and looking more like Snoopy than a Presidential candidate. And you could always tell that the camera just loved JFK and hated Richard Nixon.

Politicians have to handle babies who might throw up on their shirts, consort with critters who might peck at their pants or poop on their vests. Politicians wear other people's clothes and shake hands with any convenient appendage in their path. As you leaf through these pages you will see that George W. is no different.

The camera doesn't hate George W. the way it did Richard Nixon. And his handlers make certain that

George W. gets to the right spot at the right time. Even so, he has had trouble with his Ops and his Oops. The Mission Accomplished photo, a picture of the President as Top Gun landing a jet on an aircraft carrier, became an ironic comment on continuing hostilities in Iraq. He gets tangled up with briefcases, papers and pets as he salutes Marine guards. The pictures roll out but the difference between what they are intended to show and what the viewers receive is the distance between an Op and an Oops.

In this era of rigidly controlled and meticulously staged presidential appearances, it is a relief to be reminded that accidents do happen, sometimes for the sidesplitting benefit of us, his captive and dutiful audience.

Enjoy Bush Photo Oops.

Hal Buell

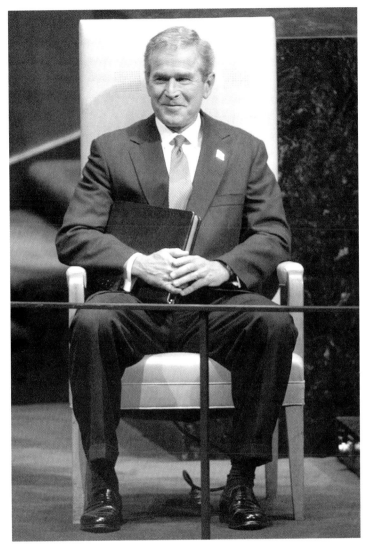

Bush, a great kidder himself, notices something is different about the Oval Office today. He thinks the desk might be gone. . .

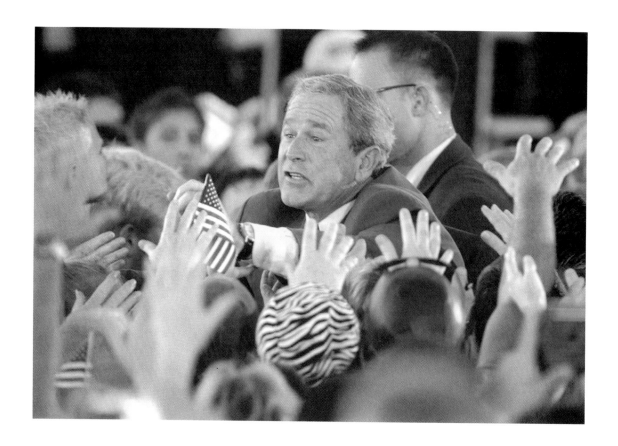

"Wait! Miss Lewinsky! Come back!! Monica! I'm the president now!"

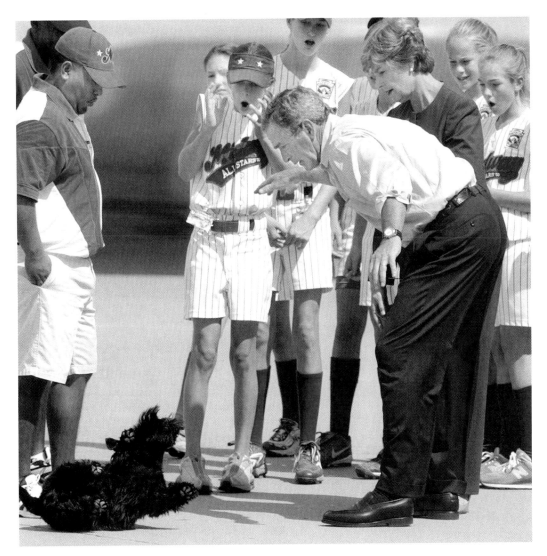

Bush flings his pet Scottie to the ground as part of his continuing "war on terriers."

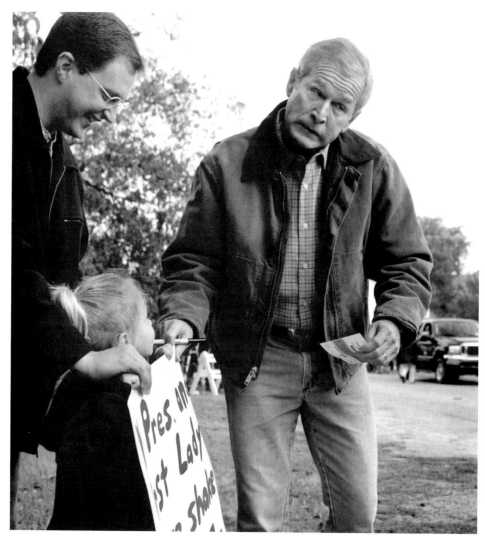

Yet another future voter falls for President Bush's favorite "pull my finger" gag.

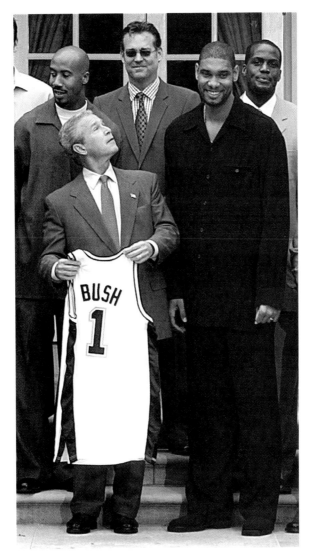

Utilizing his legendary "steel trap" mind, Bush almost immediately notices that Tim Duncan of the San Antonio Spurs is taller than he is.

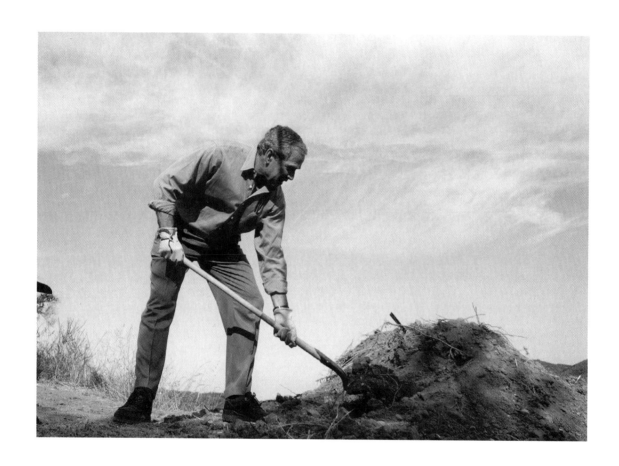

"Condy says if I throw enough of this stuff, some of it will stick."

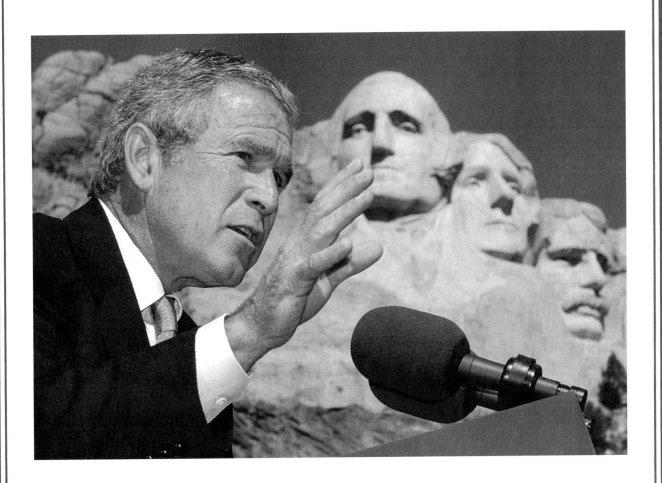

Addressing his proposed education reform, Bush asks, "How can so-called 'evolution' explain the fact that these mountains look a lot like people?"

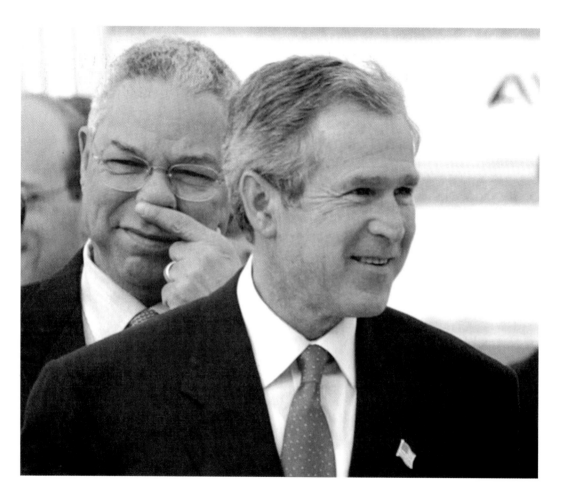

Secretary of State Colin Powell concedes there are "certain disadvantages" to being "100% behind the president at all times."

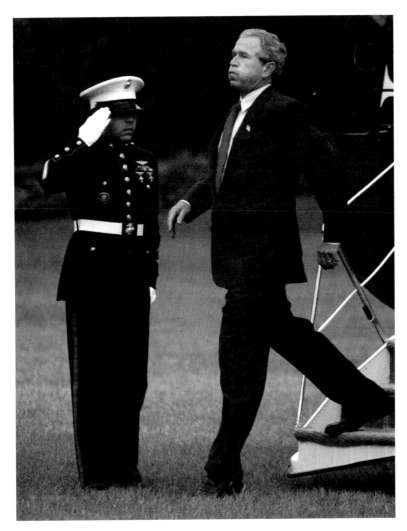

MISSION ACCOMPLISHED!

"How many Iraqis does it take to screw in a lightbulb?
Who cares - there's no ELECTRICITY! Ba-da-BOOM!"

"Over There! Over There!
Those weapons are somewhere over there!
And so the Yanks are going,
In tanks they're going,
And they won't come home 'til . . .
Ummmh . . ."

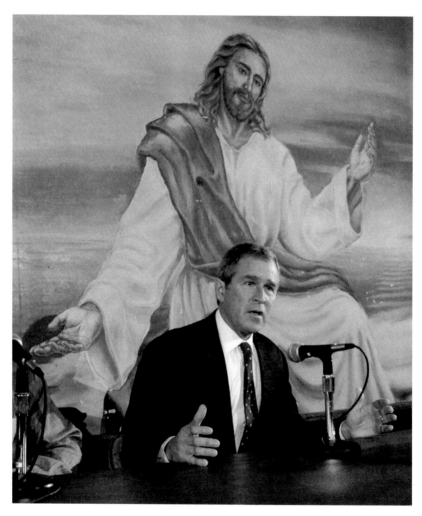

"Just think - if those ancient Romans had banned the death penalty, Jesus couldn't of died for our sins!"

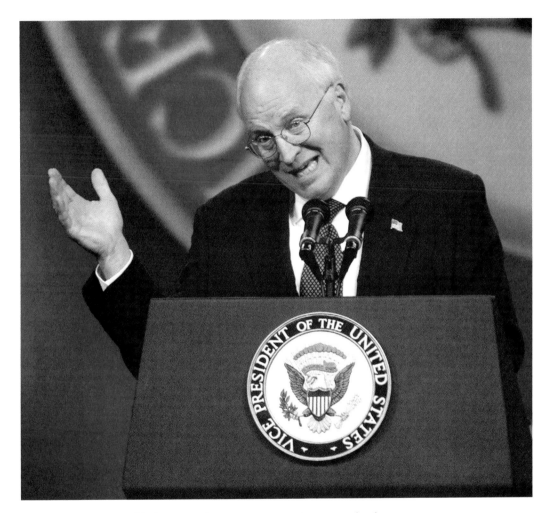

"Ask not what your country can do for you.
Ask rather what your country can do for Halliburton."

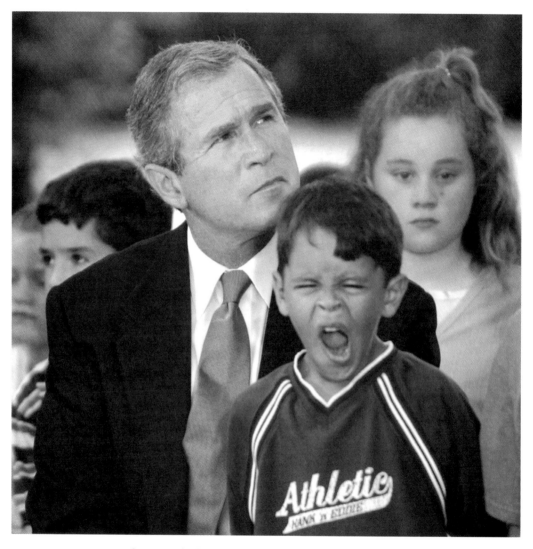

Bush unveils his entertaining ventriloquism act.
"What do you think of school vouchers, Johnny?"
"S'alright!"

"Oh, my god, am I in time? This is the governor, do not execute that woman! Hahahaha! Of course I'm kidding. Gotcha!"

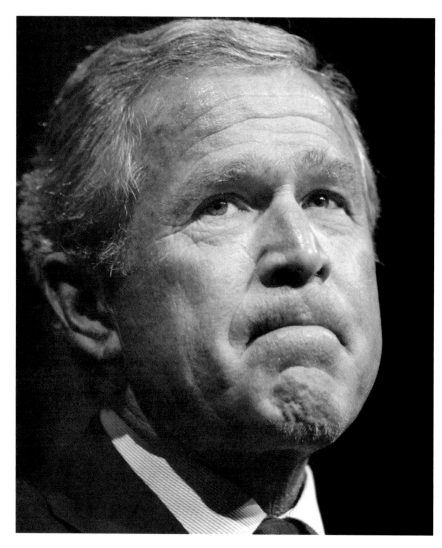

COMPASSIONATE . . .

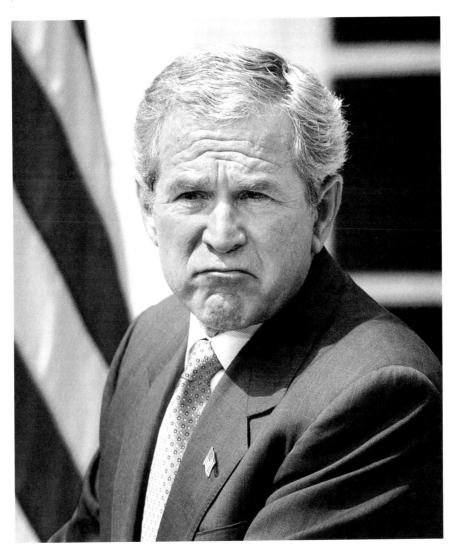

. . . CONSERVATIVE

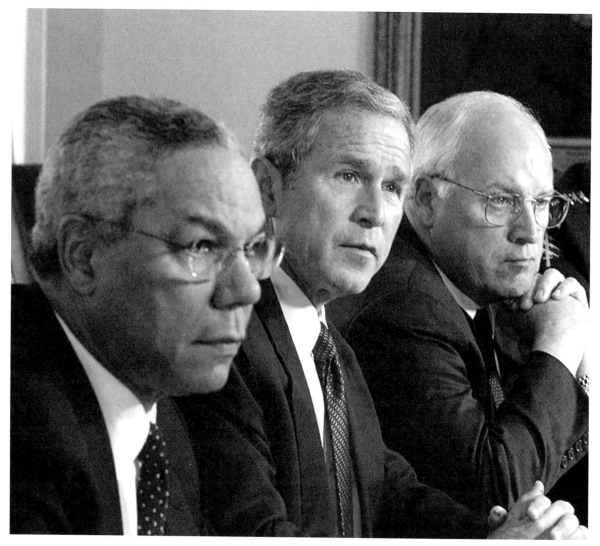

"Think no evil." "Think no." "Evil."

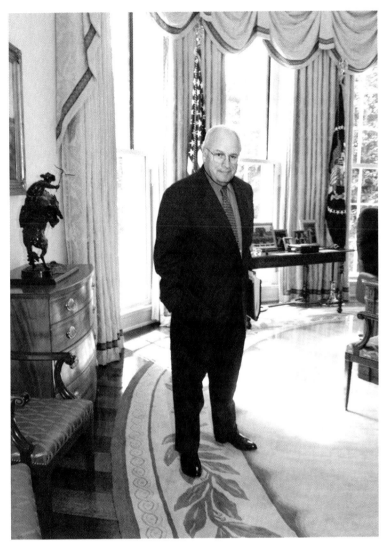

Cheney in conference with his closest advisor, Beelzebub - who is, unfortunately, unphotographable.

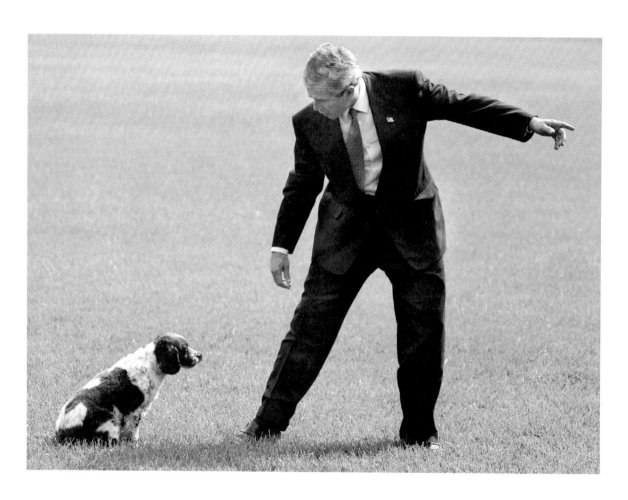

Adhering to established White House policy, presidential dog Spot declines to follow orders until "clearing them with Dick."

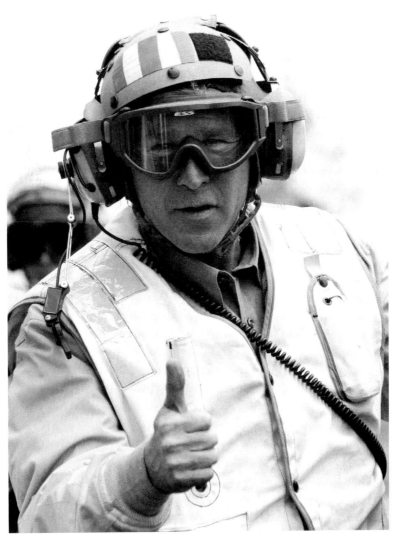

Bush proudly models new "pretzel-eating safety headgear" personally designed for him by wife Laura.

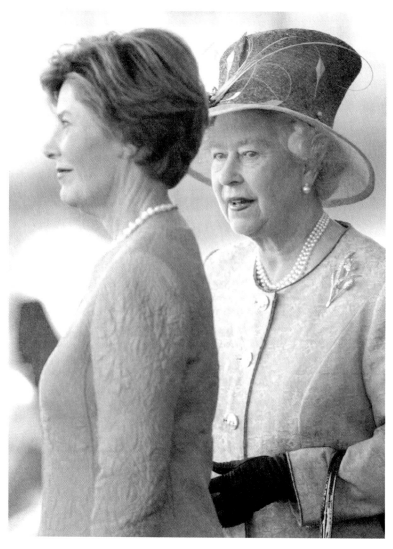

Queen Elizabeth II attempts to get the attention of First Lady Laura Bush, who is accidentally standing on one of Her Majesty's pet Corgis.

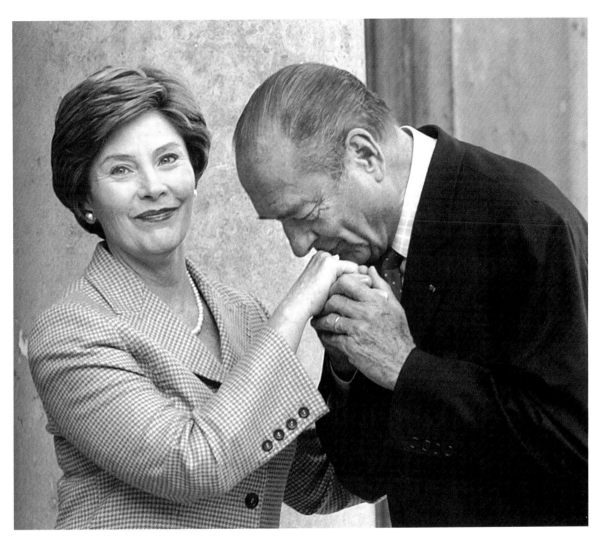

"Your 'ands, madam - they smell like - 'ow do you say it? Valium?"

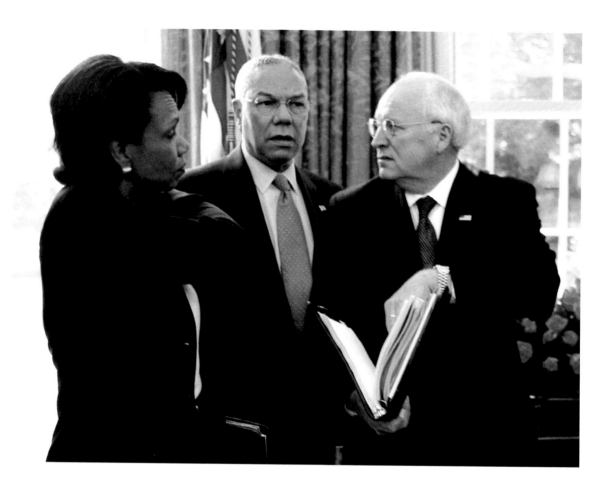

Mideast experts examine the new "Federally Authorized" English-language version of the Koran, in which *jihad* is translated as "faith-based initiative."

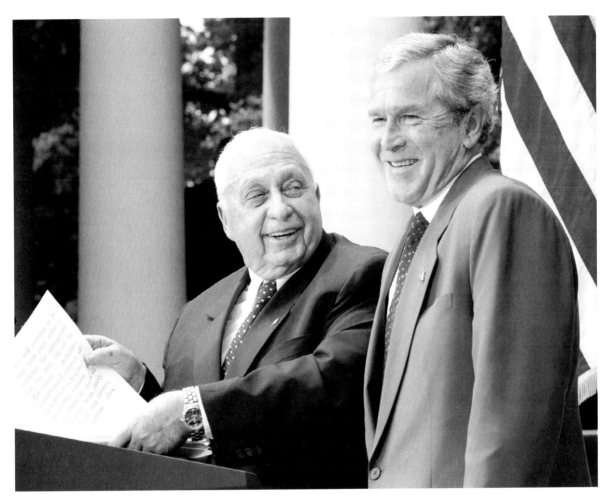

"Roadmap, shmoad map. As long as you've got your nukes."

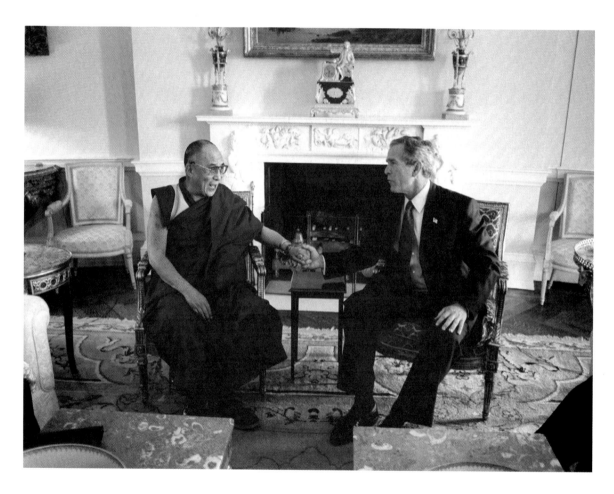

Dalai Lama tells Bush that in previous lives Bush had been Czar Nicholas II of Russia, King Louis XVI of France and King Charles I of England.

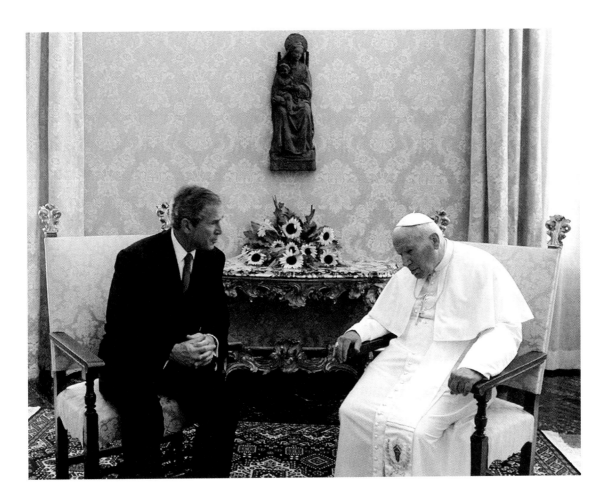

"No offense, your Popeness, but if only you knew Jesus like I do . . ."

31

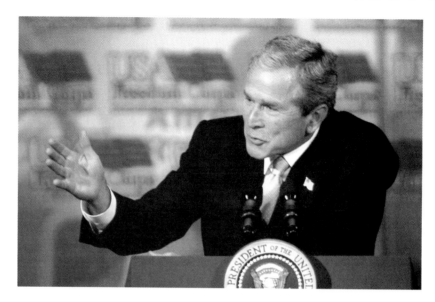

"Next question. Over here."

"Hmmmmmm"

"Hmmmmmm"

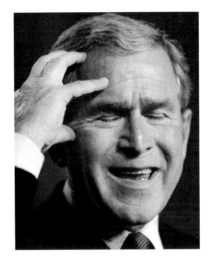

"Wait a minute!" "Laura!"

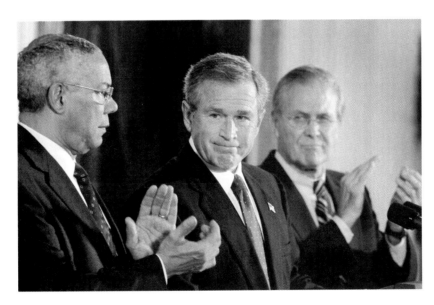

"Nice work, sir!"
"Brilliant, as usual!"

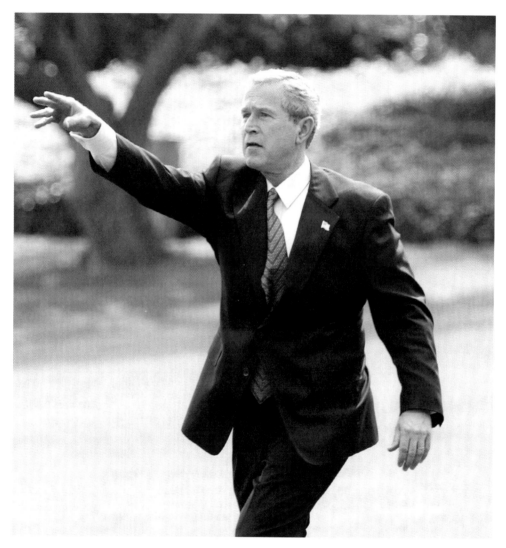

While on a fund raising tour, Bush performs "I'm a Little Tea Pot" in exchange for 60 grand from some guys who own a lead mine.

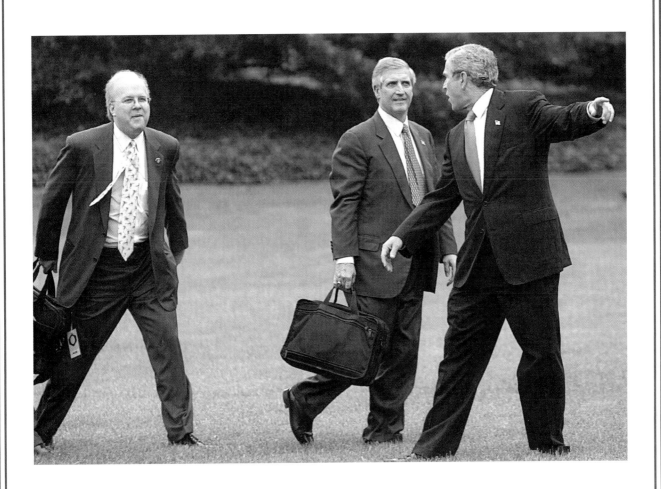

"Slow down, Mr. President. This money is heavy!"

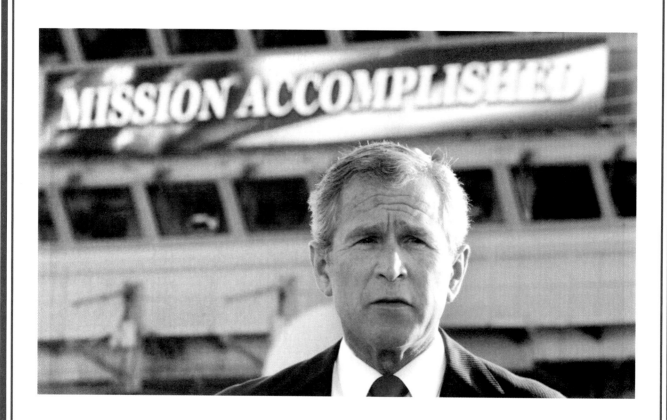

Would you buy a used war from this man?

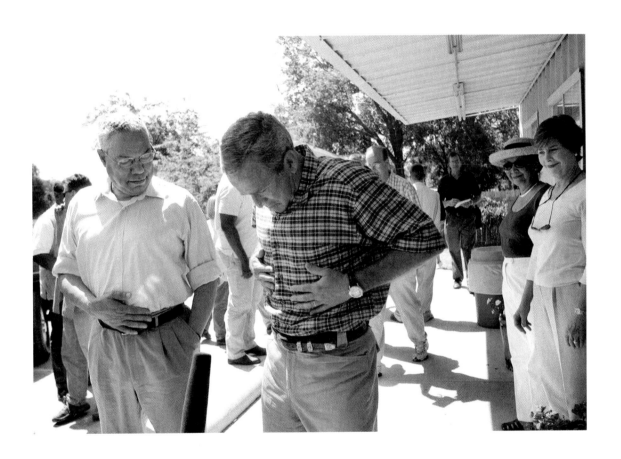

"Jeez! I could swear it was there when I woke up this morning . . ."

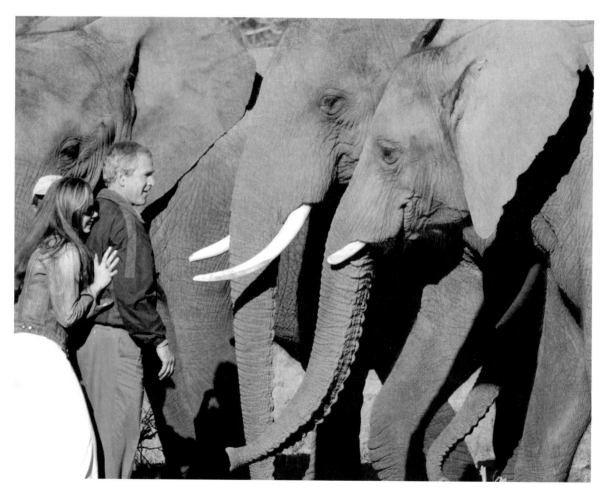

"I don't get it, Daddy. How come they aren't pink?"

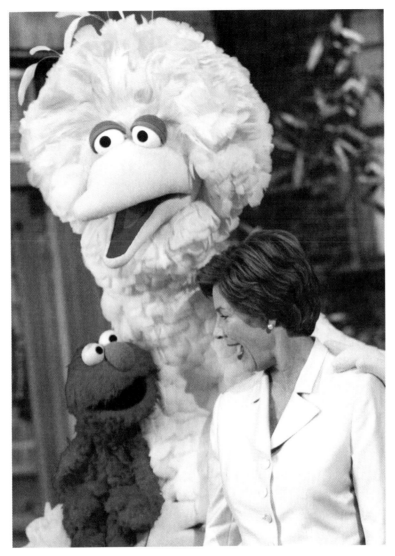

"Elmo love free trade! Elmo assembled cheap by Chinese children!"

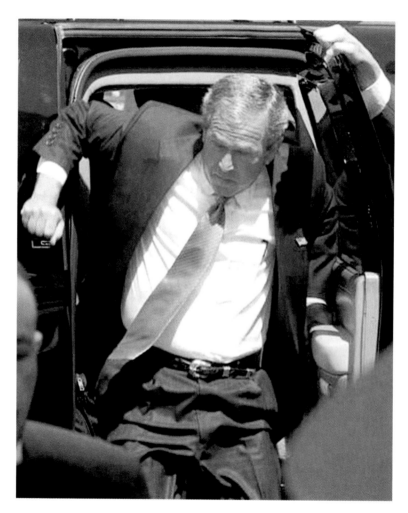

The Problem.

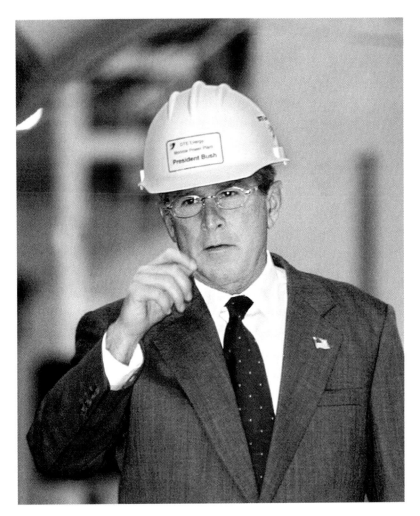

The Solution.

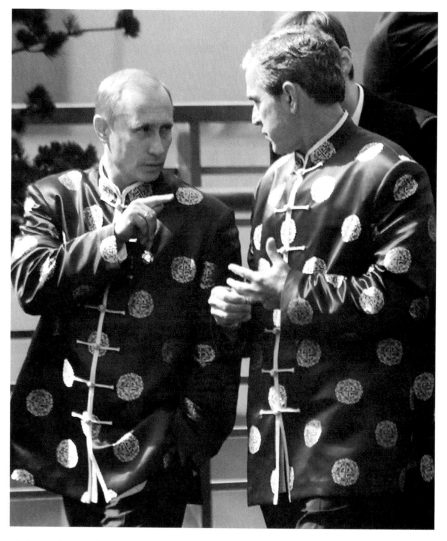

"My advice? Lose the ring. These Chinese babes don't go for married men."

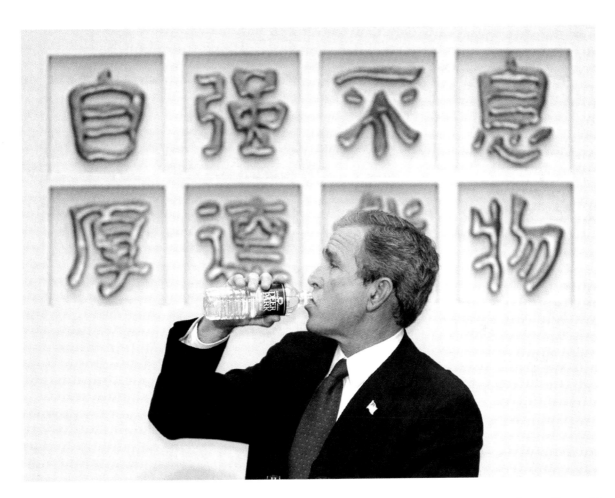

"Darn these cheap Chinese bugles! They're hard to play and they get my shirt all wet!"

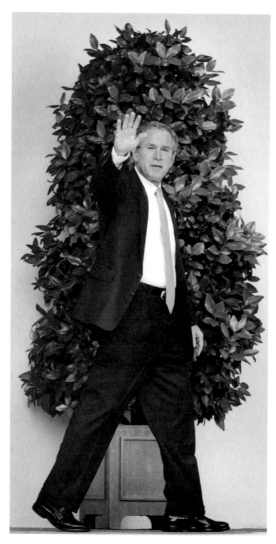

During press conferences, the White House staff usually provides
the president with visual "cues" to answer "trick" questions.
Here, he has been prepared to remember his name.

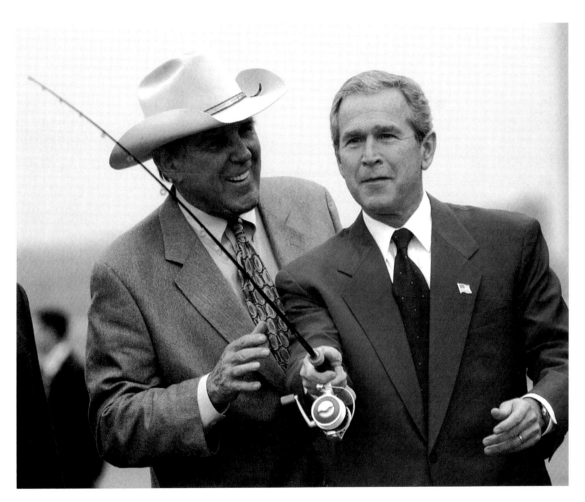

"And it works even better in water!"

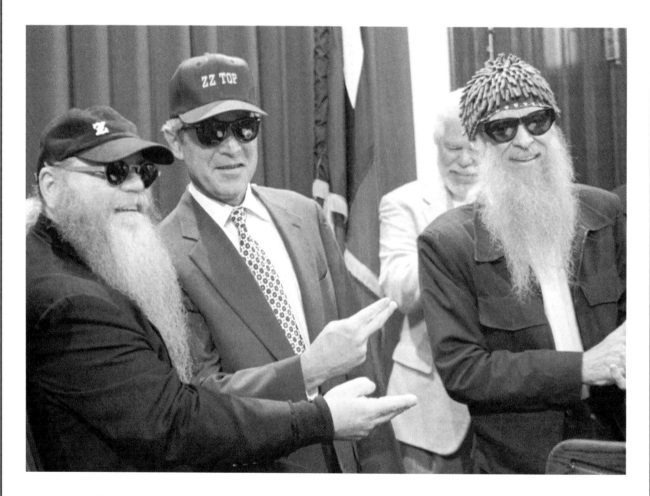

Rumors of close ties between Bush family and Saudi religious extremists remain tantalizing, but impossible to pin down.

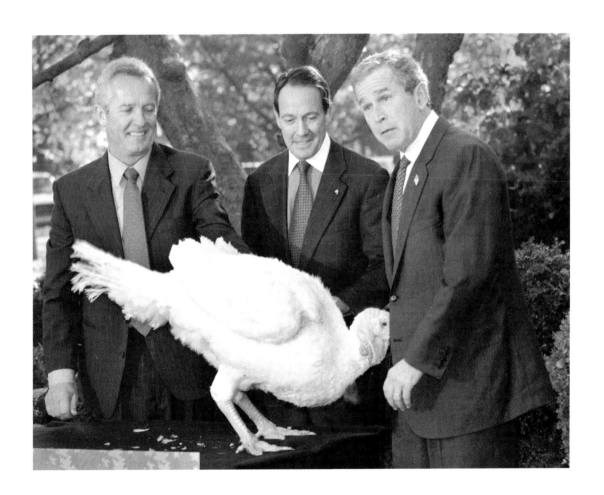

Desperate for Mideast allies, Bush woos Turkey.

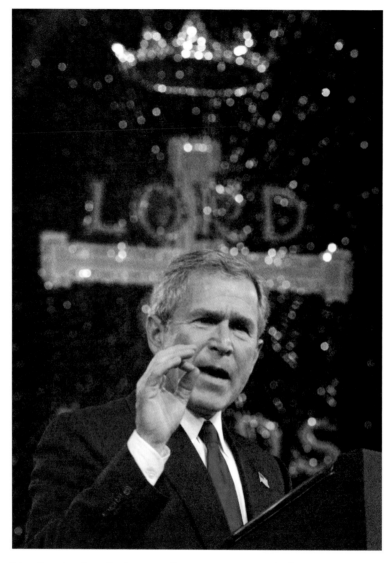

Bush expresses his thanks for their unanimous support in his War on Terror to members of the International Hawaii Five-O Fan Club.

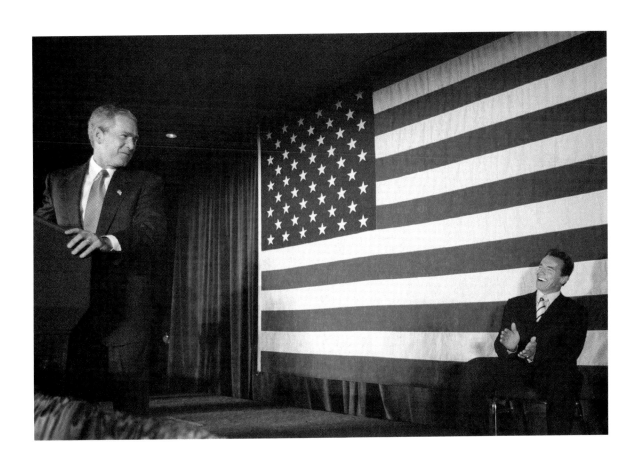

"You're not going to grab my ass, are you?"
"In your dreams!"

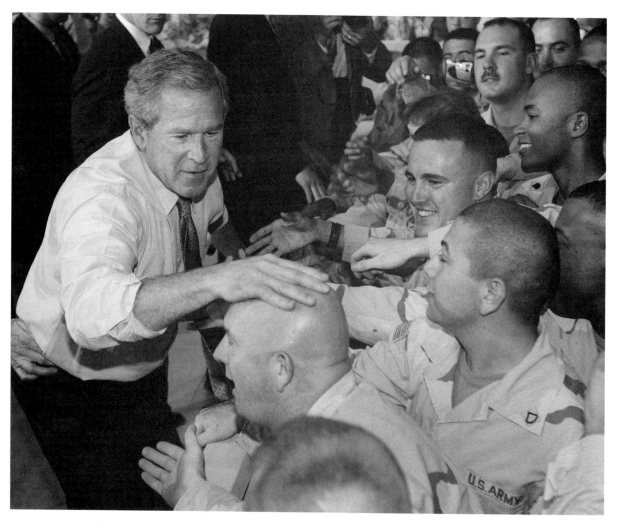

"Curly?! Ho-ho, Mr. President, how do you come up with them?"

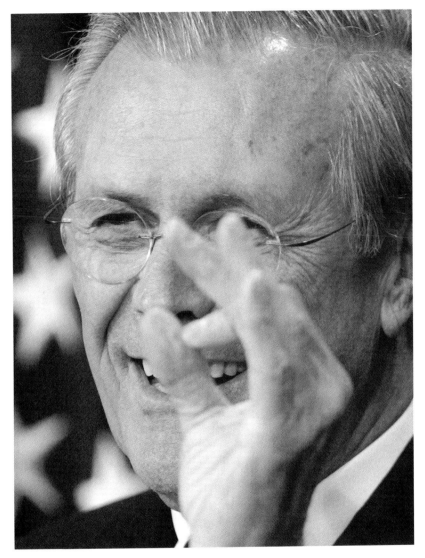

Rumsfeld assures public that rising US casualties, increasing sabotage incidents and utter humiliation were all elements of "carefully thought-out pre-war strategy."

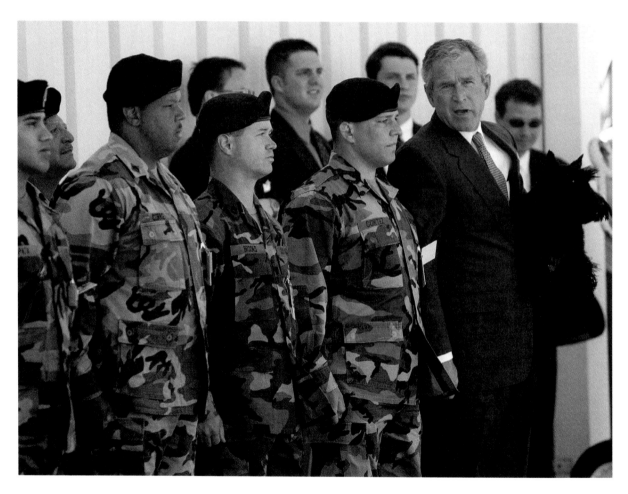

"You'll like Iraq. It's real nice. Of course, I wouldn't send a dog there . . ."

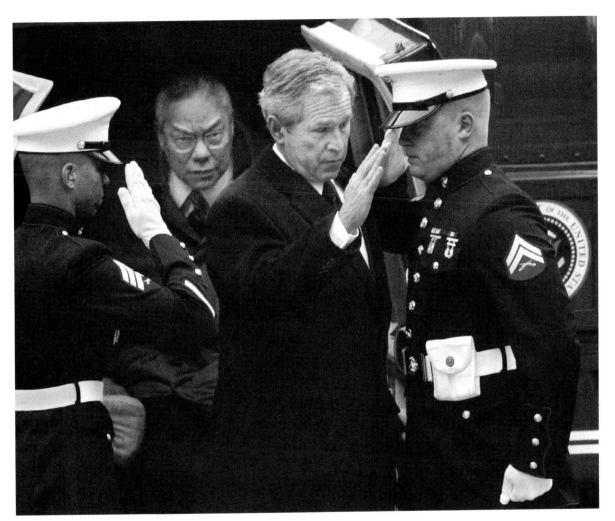

"Hey, soldier. Run and get me a turkey sandwich with cranberry sauce.
Bring it to me and I'll give you half."

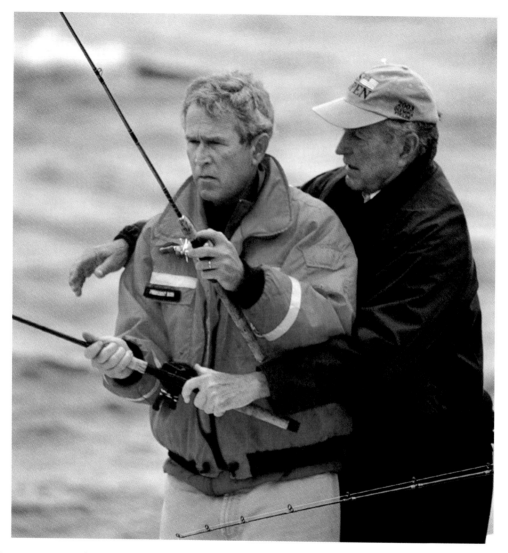

"Give a man a fish and you feed him for a day - but eliminate the inheritance tax and you've hooked him for life."

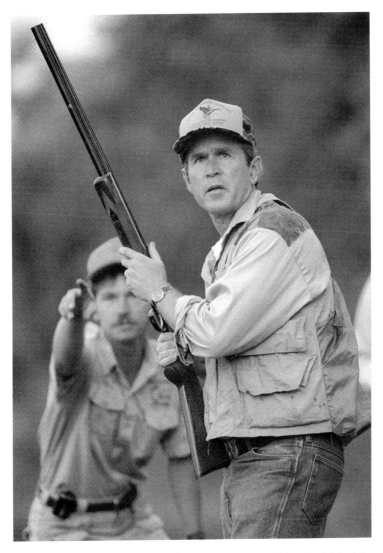

"That's not a peasant! That's just some kind of bird."

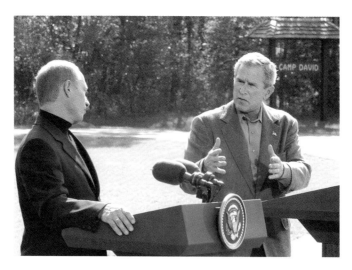

"Before we start negotiatin' here, Vlad, there's somethin' you should know about me. Somethin' personal . . ."

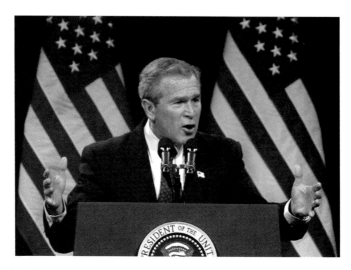

"And then I told the Russian premier - I told him straight out. I said, Mr. Putin, lemme tell you the kind of man I am . . ."

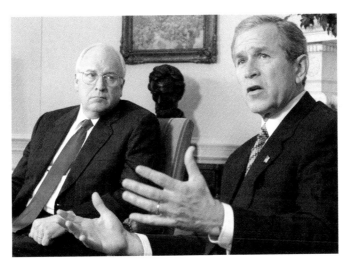

"Now that's the kind of exaggerationisms you see in the so-called liberal media. What I really said was somethin' more like . . ."

"In the light of recent evidence, the President would like to slightly revise certain previous statements . . ."

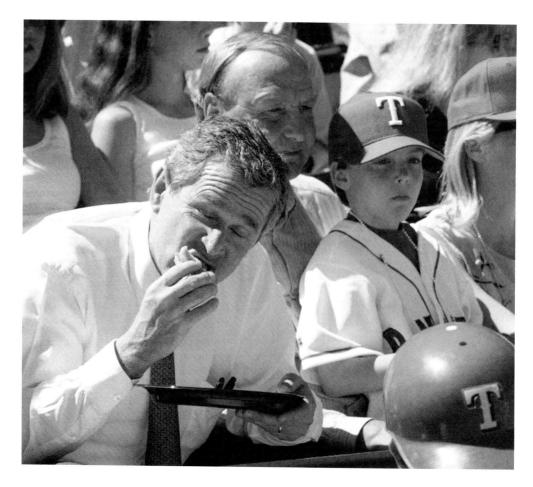

President takes break from rescinding decades of habitat protection on public lands to attend ball game and enjoy a juicy "endangered species burger."

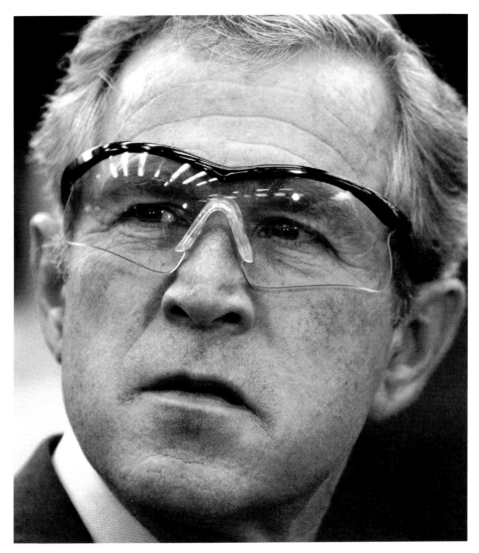

While visiting a coal burning power plant, the president explained that eliminating emissions controls would "lead to cleaner air." Shortly after this photo was taken, he removed his goggles and his eyeballs burst into flame.

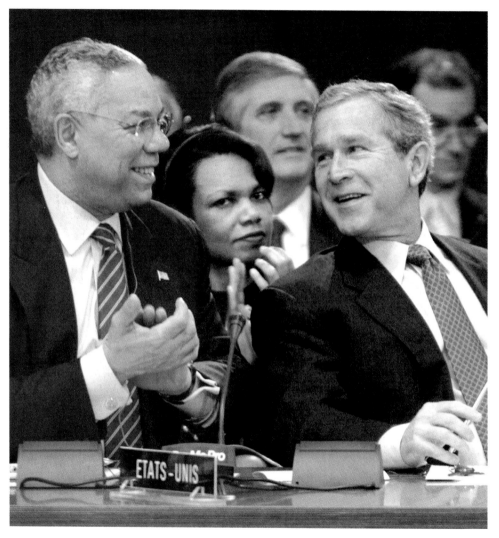

Rumsfeld gets a well-deserved laugh from Bush and Powell, as he thanks members of the Coalition of the Willing for helping US to make "a Mess o' Potamia."

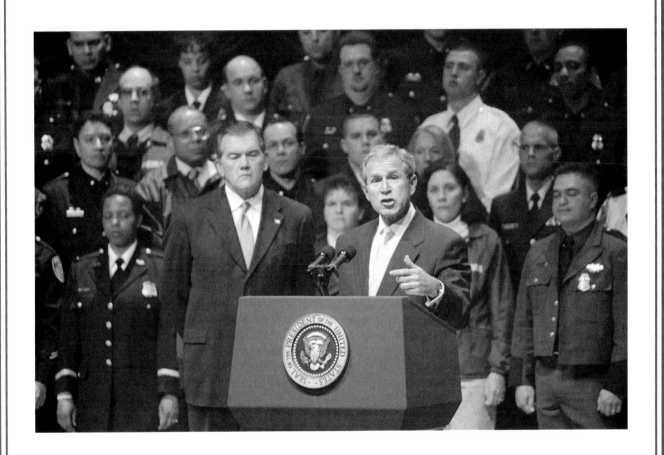

Responding to the "gay marriage" crisis, the president instructs
Tom Ridge to put the entire nation on "Lavender Alert."

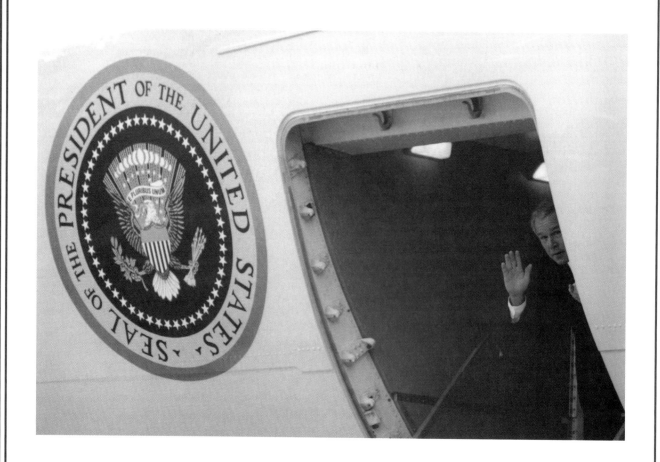

When Freedom's foes attacked the American homeland, the Commander in Chief took decisive action.

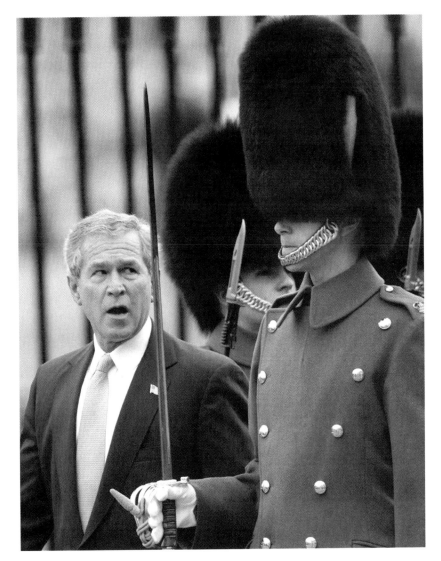

Bush inspects an honor guard at Buckingham Palace, London. He was later overheard asking the Queen, "How do they get their hair to stay like that?"

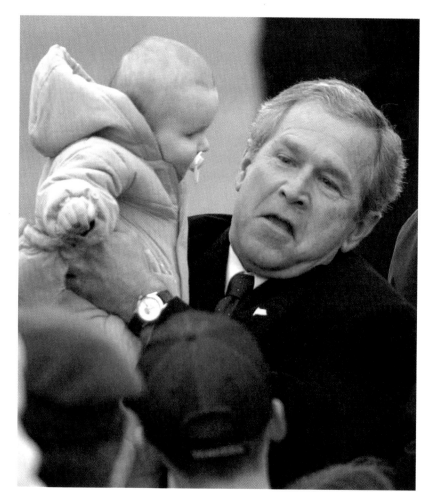

MISSION ACCOMPLISHED!

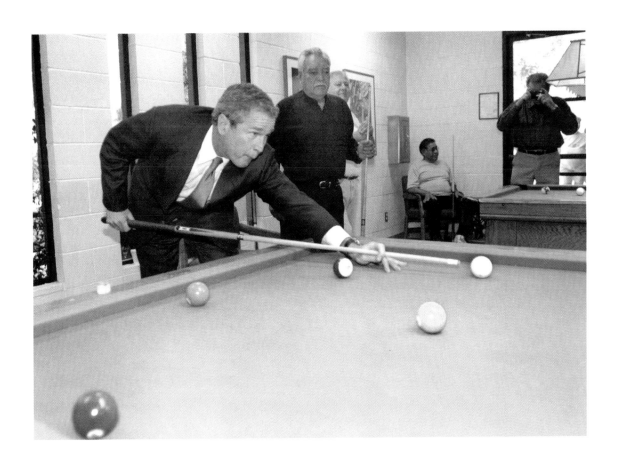

Bush calls his shot. "Cue ball in the corner pocket."

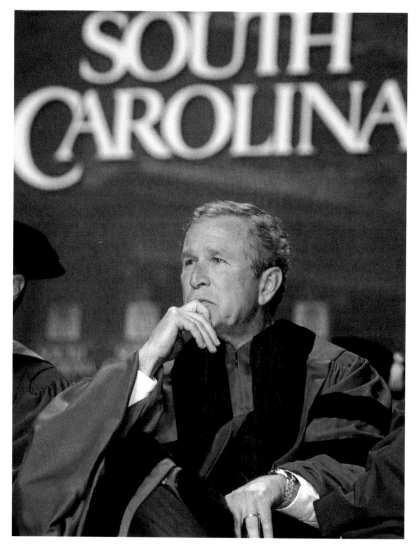

"Now lemme see, am I in North or South Carolina?"

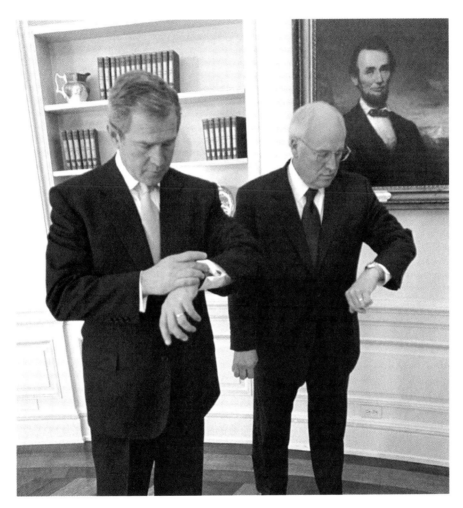

"Okay, Dickie Boy, let's simonize our watches."

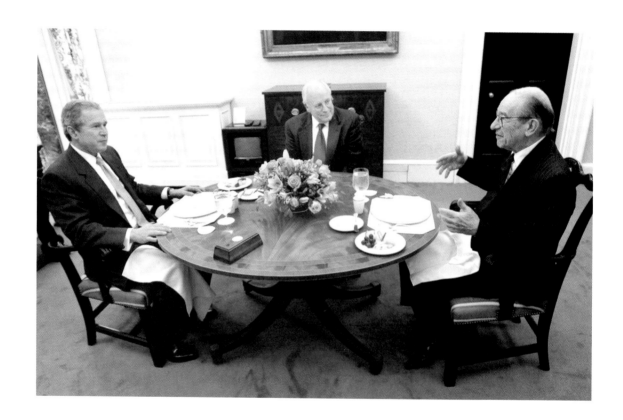

Greenspan tells Bush and Cheney how he discovered that "the economy is stimulated when interest rates go rapidly up and down, up and down, up and down."

Temporarily without Congressional cover, Bush pretends that cuts to Head Start and Americorps are actually coming from his dog Barney.

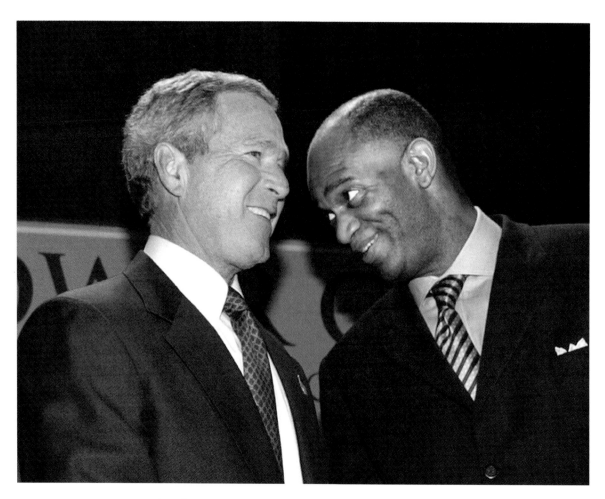

Pastor checks to see if there's light at the end of the tunnel.

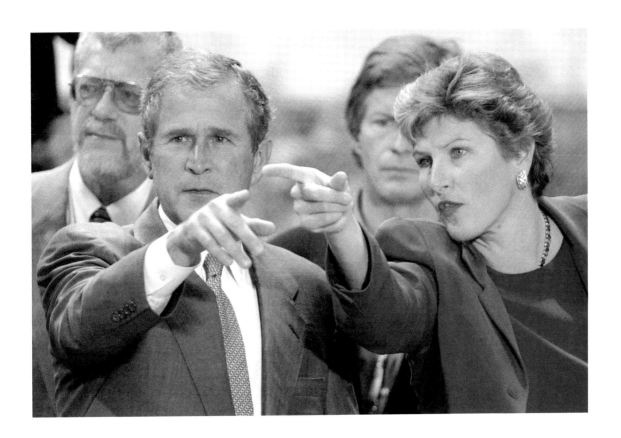

Preparing for a press conference, Hughes rehearses Bush in the difficult technique of "pointing to the right."

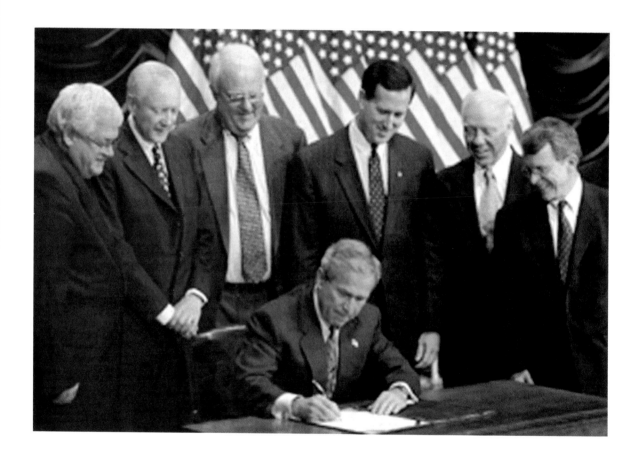

Bush and a group of his closest theological advisers take a solemn vow never to personally undergo an abortion.

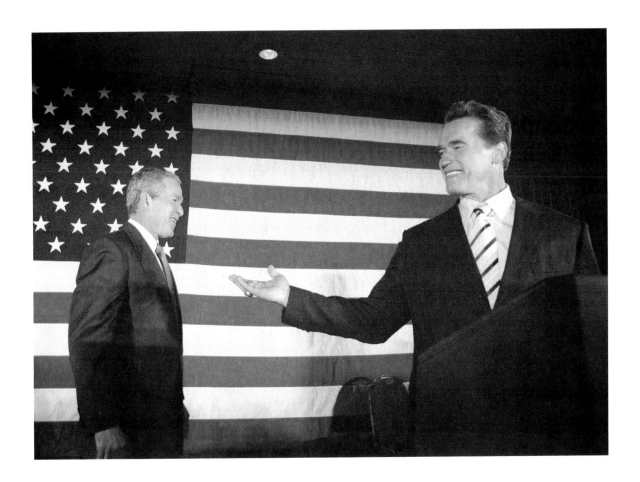

Where but in America could the son of a simple Nazi police chief get to meet
the son of the former head of the CIA?

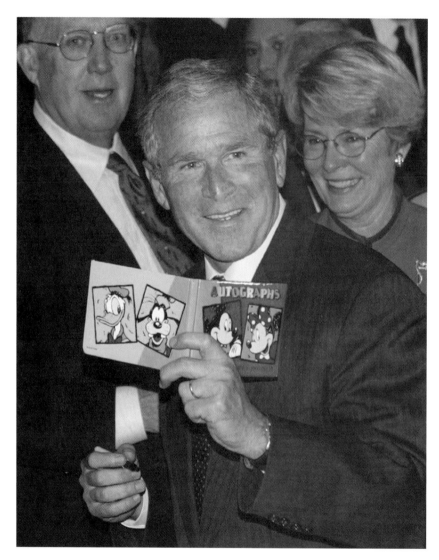

CIA report on Iraq finally came through!

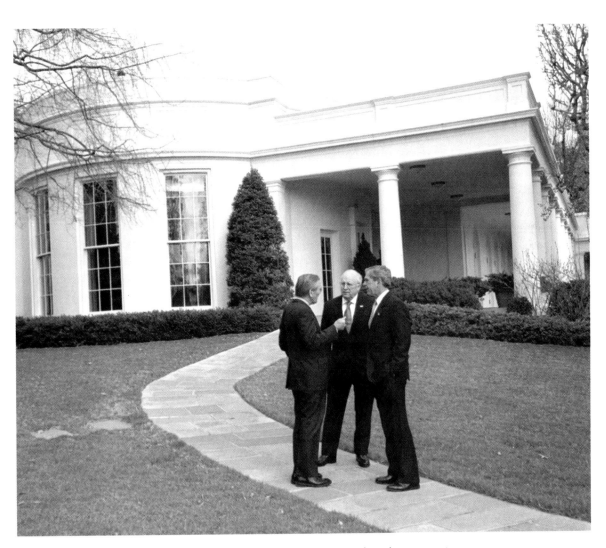

"Time for war games. George, you be the Americans.
Dick, you be Uday and I'll be Qusay."

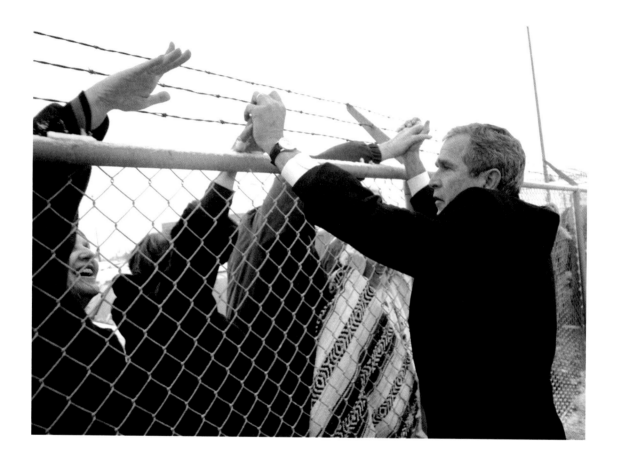

Bush pays a surprise visit to a group of suspected liberals confined in one of the many "Homeland Security Camps" established under the Patriot Act.

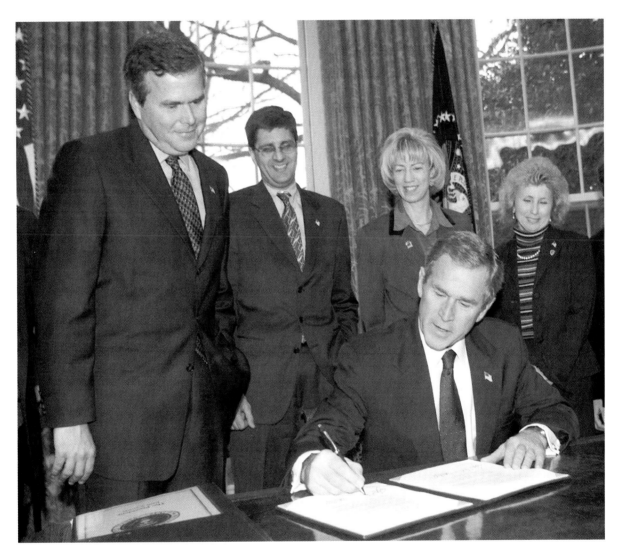

Bush signs bill leaving Republic to younger brother Jeb. Jeb promises eight years of tax cuts,
hyper-conservative judicial appointments and "war with . . . I dunno . . . somebody . . .
maybe Peru."

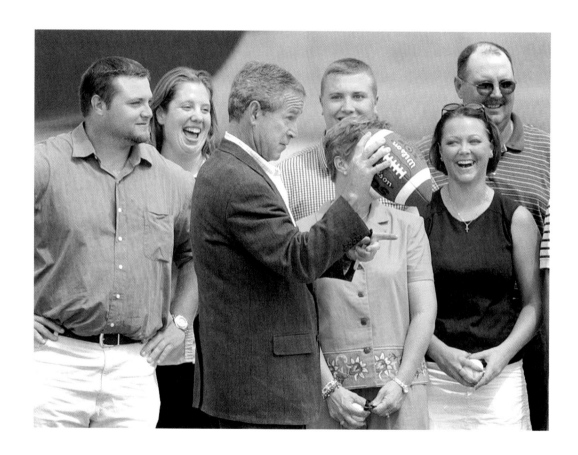

Bush demonstrates the "intentional grounding" tactic used when the QB can find neither an open receiver nor a single Weapon of Mass Destruction.

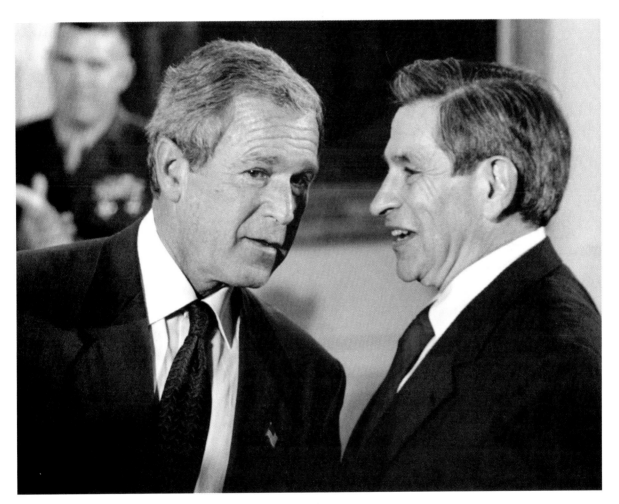

Wolfowitz assures Bush that despite "certain minor unforeseen difficulties" in Iraq, North Korea will be "a slam dunk".

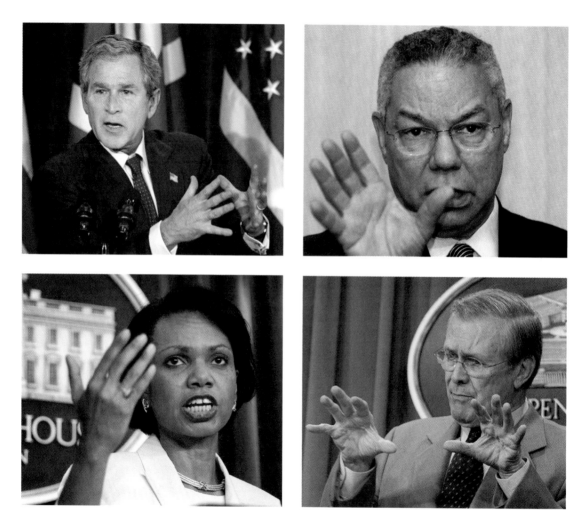

Watch very carefully. Notice our fingers never leave our hands.

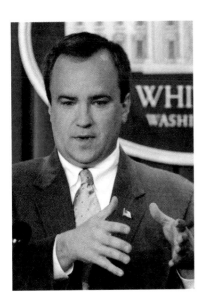 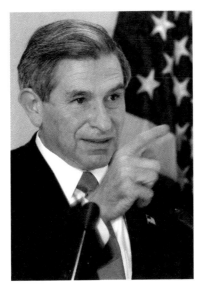 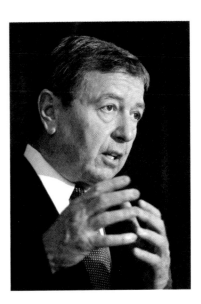

And ZAP! The surplus has vanished!

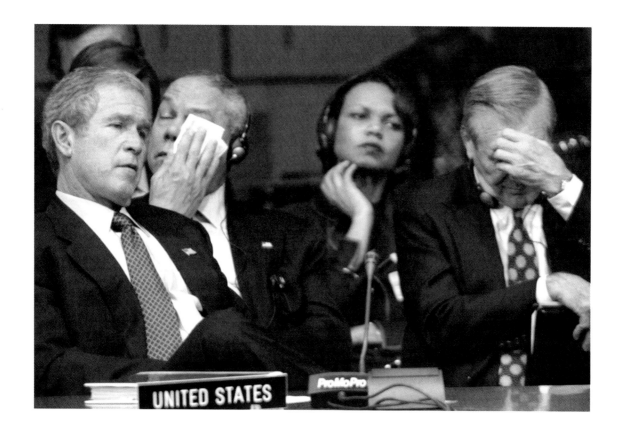

His closest advisors are learning to accommodate the President's lactose intolerant condition.

82

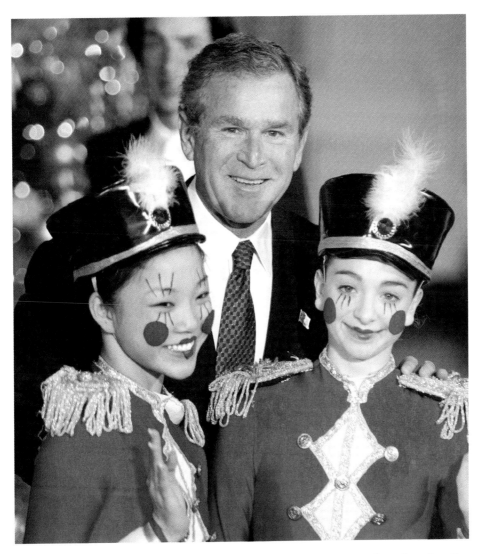

Bush introduces members of the new Homeland Security "fear-leading" squad.

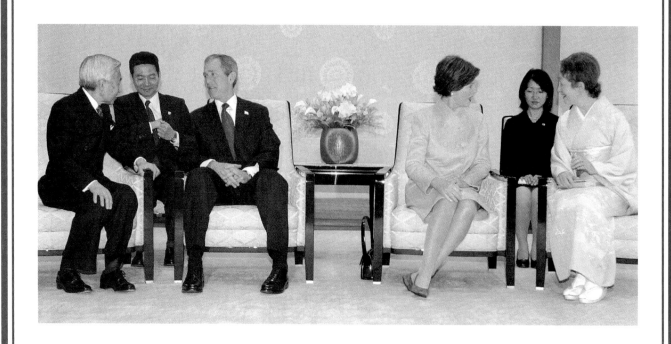

On Asian tour, presidential translator struggles to find Japanese word for "economyize," while God, in his mercy, permits the First Lady's translator to fall asleep.

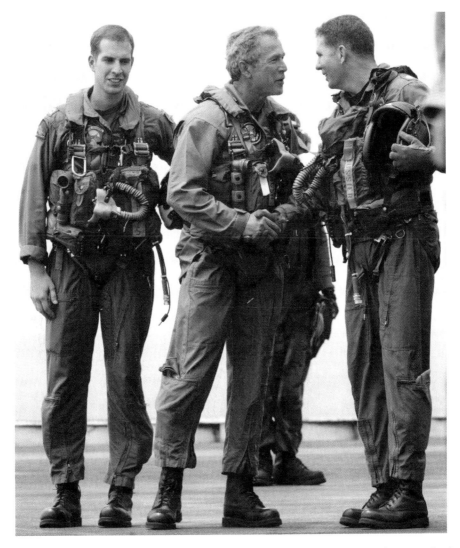

"I can't tell you the last time I wore one of these. I'm serious. Those whole three years are a blur."

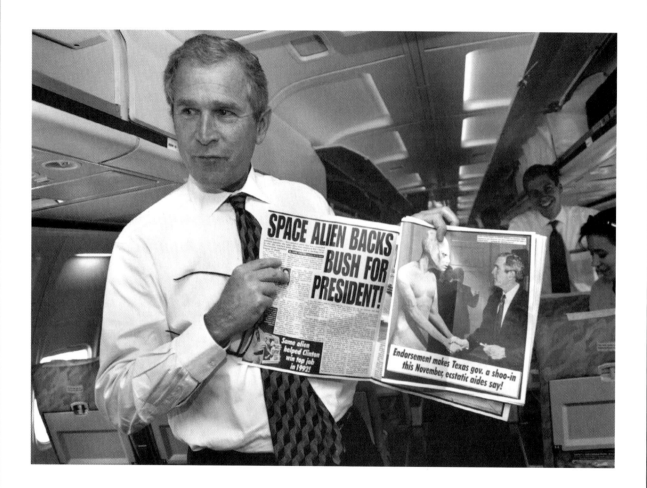

"There's gonna be hell to pay when I find out who leaked this to the liberal media!"

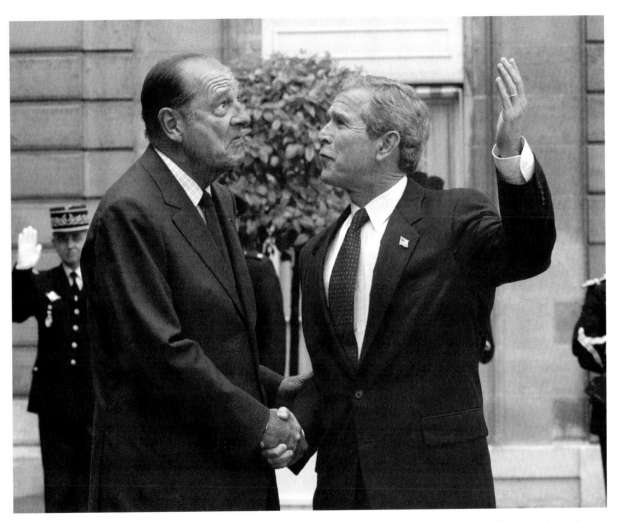

Bush prepares to slap Chirac across the face, while calling him a "smelly, snail-eating surrender monkey."

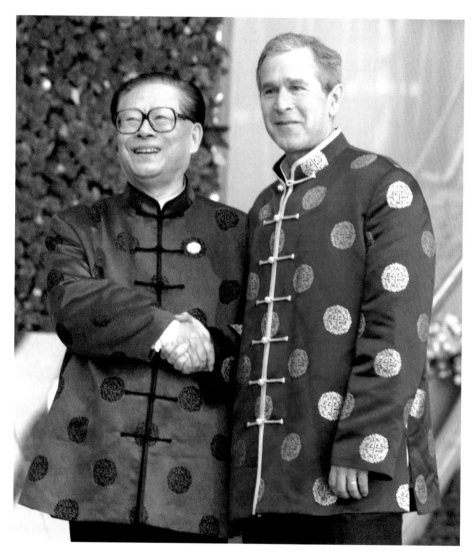

Bush thanks Zemin for the nifty PJs.

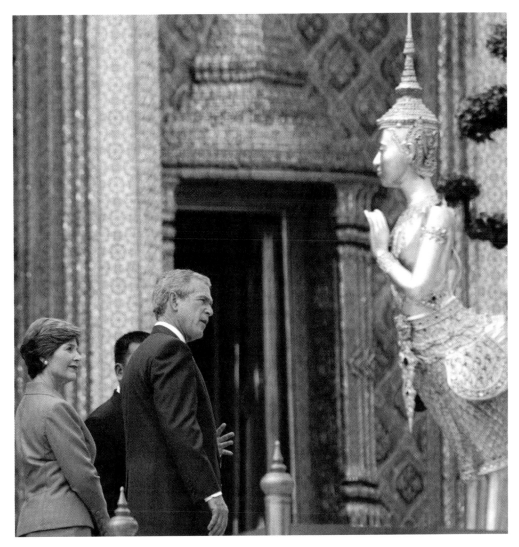

In Bangkok, Thai officials assure Bush that they will show his brother Neil a good time when he's here, and not call him "Fredo."

"Brrr! Musta got it wrong! Maybe it's the salt first, then the tequila, then the lime . . ."

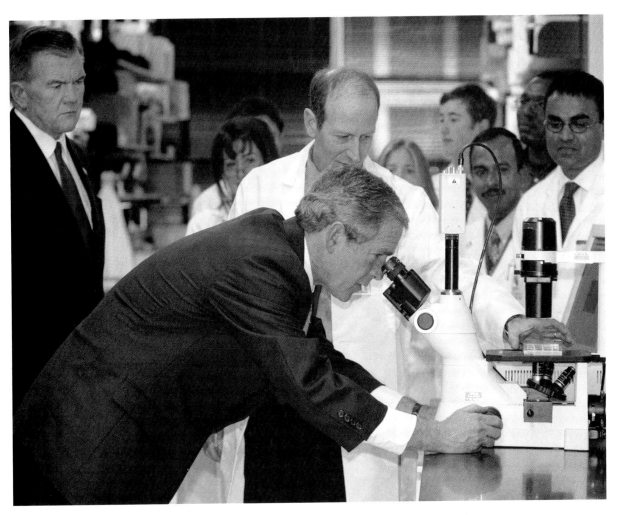

Bush continues the relentless search for Osama Bin Laden and Iraq's weapons of mass destruction.

An enthusiast for "X-treme Sports," the President executes the difficult "Freestyle Segway Double Klutz with Full Face-plant."

"Mission accomplished. Hello? I said Mission Accomplished!"

Photo Captions

Page 5. President Bush waits to address the United Nations General Assembly, September 23, 2003.

Page 6. President Bush reaches to shake hands of supporters at a campaign stop in London, KY, on behalf of Ernie Fletcher, who was running for governor, November 1, 2003.

Page 7. President Bush accidentally drops his dog Barney to the tarmac upon arrival in Waco, TX, August 30, 2003. Barney was not hurt.

Page 8. President Bush, in Crawford, TX, November 5, 2002, reacts to a child who asks him if he would attend the child's birthday party. The president replied that the invitation must have been lost in the mail.

Page 9. President Bush poses with National Basketball Champions the San Antonio Spurs at the White House, October 14, 2003.

Page 10. President Bush helps fill in erosion damage with volunteers during a visit to Santa Monica mountains in Thousand Oaks, CA, August 15, 2003.

Page 11. President Bush speaks on homeland security and the budget at the base of Mount Rushmore National Memorial in South Dakota, August 15, 2002.

Page 12. President Bush and Secretary of State Powell arrive in Rome for a meeting with European heads of state, May 27, 2002.

Page 13. President Bush passes a saluting Marine as he returns to the White House via helicopter, September 4, 2003.

Page 14. President Bush speaks on the economy while visiting Beaver Aerospace and Defense in Livonia, MI, July 24, 2003.

Page 15. President Bush addresses the Republican National Committee gala in Washington, DC, October 8, 2003.

Page 16. President Bush sits in front of a painting of Jesus Christ as he addresses Teen Challenge of the Midlands at their meeting in Colfax, IA, June 21, 2000.

Page 17. Vice President Cheney addresses the National Minority Enterprise Development Week Conference at a Washington hotel, September 30, 2003.

Page 18. Youngster yawns as Presidential candidate George Bush listens to Colin Powell speak in Austin, TX, May 25, 2000.

Page 19. President Bush speaks with Japan Prime Minister Junichiro Koizumi, March 10, 2003.

Page 20. President Bush, a portrait, tight lipped.

Page 21. President Bush photographed with a scowl on his face, July 3, 2002.

Page 22. President Bush sits with the National Security Council during a meeting in the White House September 12, 2001. With him are Secretary of State Powell, left, and Vice President Dick Cheney.

Page 23. Vice President Dick Cheney stands in the Oval Office at the White House during a meeting between President Bush and South Korean President Kim Dai-jung, March 7, 2001.

Page 24. President Bush gestures to his dog, Spot, on the White House lawn after returning from a trip to New Jersey, September 23, 2002.

Page 25. President Bush is thumbs up aboard the aircraft carrier USS Abraham Lincoln, May 1, 2003.

Page 26. Laura Bush and Queen Elizabeth at a welcoming ceremony on the arrival of President Bush in England, November 19, 2003.

Page 27. French President Jacques Chirac kisses the hand of Laura Bush upon her arrival for a courtesy call at the Elysee Palace in Paris, September 29, 2003.

Page 28. National Security Advisor Rice, Secretary of State Powell and Vice President Cheney confer in the White House prior to a meeting with the President, June 6, 2003.

Page 29. President Bush and Israeli Prime Minister Ariel Sharon laugh while making statements in the Rose Garden in Washington, July 29, 2003.

Page 30. President Bush meets the Dalai Lama in the White House, September 11, 2001.

Page 31. Pope John Paul II and President Bush talk during their first meeting at the Pope's summer residence at Castel Gandolfo, July 23, 2001.

Pages 32. Top: President Bush in Bridgeport, CT, April 9, 2002; bottom left: in Washington, DC, September 4, 2003; bottom right: in Chicago, September 30, 2003.

Page 33. Top left : in Milwaukee, October 3, 2003; top right: in Portsmouth, NH, October 9, 2003; bottom: with Powell and Rumsfeld, Washington, November 6, 2003.

Page 34. President Bush pretends to throw a ball to visiting youngsters as he heads for his helicopter on the White House lawn, September 26, 2003.

Page 35. President Bush talks to Chief of Staff Andrew Card, center, and political advisor Karl Rove as they walk across the White House lawn, July 28, 2003.

Page 36. President Bush speaks to the crew of the carrier USS Abraham Lincoln, declaring that major combat actions in Iraq are complete, May 1, 2003.

Page 37. President Bush reacts to reporter's question about his weight during a stop at Coffee Station restaurant in Crawford, TX, August 6, 2003. Secretary of State Powell is at left.

Page 38. President Bush and his daughter, Barbara, walk up to elephants at the Mokolodi Nature Reserve in Gaborone, Botswana, July 10, 2003.

Page 39. Laura Bush with Elmo and Big Bird, of Sesame Street, after taping a segment for a television show for children, New York, September 19, 2002.

Page 40. President Bush leaves his helicopter after landing on the White House lawn.

Page 41. President Bush wears a hard hat and goggles as he tours the Detroit Edison Monroe Power Plant in Monroe, MI, September 15, 2003.

Page 42. Russian Prime Minister Vladimir Putin with President Bush as they make their way to a meeting in Shanghai, China, October 21, 2001.

Page 43. President Bush takes a drink of water during a discussion with Chinese students in Beijing, February 22, 2002. Background characters refer to the school's motto urging hard work and morality.

Page 44. President Bush waves as he walks out of the Oval Office, October 24, 2003.

Page 45. President Bush examines a rod and reel given to him by Ray Scott, upon Bush's arrival in Montgomery, AL, October 24, 2002, to support local candidates.

Page 46. Texas Governor George Bush, after signing a proclamation honoring the ZZ Top rock group, poses with the group wearing glasses and a cap presented to him, May 15, 1997.

Page 47. The turkey brought to the White House to mark Thanksgiving Day makes a sudden lunge for President Bush during the annual turkey outing.

Page 48. President Bush speaks at the dedication of the Oak Cliff Bible Fellowship's Youth Education Center in Dallas, TX, October 29, 2003.

Page 49. President Bush turns to look at Governor-elect Arnold Schwarzenegger during a speech in San Bernardino, CA, October 16, 2003.

Page 50. President Bush reaches out to pat the bald head of an American soldier during his visit to Iraq, June 5, 2003.

Page 51. Secretary of Defense Rumsfeld briefs media October 30, 2003, at the Pentagon.

Page 52. President Bush holds his dog, Barney, as he poses for a picture with the 149th Infantry Military Police unit from Fort Hood, TX.

Page 53. President Bush salutes Marine guard as he and Secretary of State Powell exit a helicopter in Belfast, Northern Ireland, April 7, 2003.

Page 54. Former President Bush switches fishing poles with his son, President Bush, during a fishing trip off Kennebunk, ME, June 15, 2003.

Page 55. George Bush, then a candidate for governor, spots a bird during a hunting outing in Texas, September 1, 1994.

Page 56. Top: President Bush and Russian President Vladimir Putin hold a press conference at Camp David, September 27, 2003, after two days of talks. Bottom: President Bush speaks at a fund raising dinner at Riverside Convention Center in Riverside, CA, October 15, 2003.

Page 57. Top: President Bush and Vice President Cheney meet in the Oval Office March 21, 2002. Bottom: Treasury Secretary gestures during an address before the U.S. Chamber of Commerce in Washington, March 4, 2003.

Page 58. Texas Governor George Bush eats a hot dog at a ball game in Arlington, TX, March 31, 1998.

Page 59. President Bush wears protective goggles during a tour of the Sears Manufacturing Co. in Davenport, IA, September 16, 2002.

Page 60. President Bush and Secretary of State Powell are shown at the NATO Security Council meeting in Prague, November 21, 2002.

Page 61. President Bush speaks at a ceremony launching the new Homeland Security Department as Homeland Secretary Tom Ridge, left, looks on, February 28, 2003.

Page 62. President Bush waves from the doorway of Air Force One as he heads for Florida, November 13, 2003.

Page 63. President Bush inspects Honor Guard on his arrival at Buckingham Palace, November 19, 2003.

Page 64. President Bush holds a child as he is greeted by families working at RAF Aldergrove in Belfast, Northern Ireland, April 7, 2003. He was to meet British Prime Minister Tony Blair.

Page 65. Republican presidential candidate George Bush plays pool during a visit to a senior center in Cucamonga, CA, May 15, 2000.

Page 66. President Bush awaits his turn to speak at the University of South Carolina commencement, May 9, 2003.

Page 67. President Bush and Vice President Cheney check their watches after the ceremonial swearing in ceremony for Secretary of State Colin Powell.

Page 68. President Bush and Vice President Cheney meet over lunch with Federal Reserve Chairman Arthur Greenspan at the White House, February 2001.

Page 69. President Bush picks up his dog, Barney, as they board Air Force One in Waco, TX, for the return trip to Washington at the conclusion of their vacation, August 30, 2003.

Page 70. President Bush with Pastor Kirbyjon Caldwell, Founder, Community Development Corporation, as the president promotes his faith-based initiative in Houston, September 12, 2003.

Page 71. George Bush and his communications director Karen Hughes stand on the podium of the Republican National convention August 2, 2000, as Bush practices for his appearance seeking nomination.

Page 72. President Bush wipes his brow as he addresses a group at Ice Harbor Lock and Dam near Burbank, WA, August 22, 2003.

Page 73. President Bush and California Governor-elect Arnold Schwarzenegger together before Bush made a speech in San Bernardino, CA, October 16, 2003.

Page 74. President Bush holds up a cartoon autograph book given to him at a fund raising luncheon in Chicago, September 30, 2000.

Page 75. President Bush meets with Vice President Cheney and Secretary of Defense Rumsfeld outside the White House, March 19, 2003.

Page 76. Texas Governor George Bush greets a small crowd through a fence at the Cheyenne, WY, airport March 9, 2000, as Bush campaigned for the presidency.

Page 77. President Bush with his brother Florida Governor Jeb Bush, standing left, signs bill, to support the Everglades restoration program January 9, 2001.

Page 78. President Bush poses with a group of well wishers and feigns a football pass at Waco, TX, August 14, 2003, before leaving on a two day trip to California.

Page 79. President Bush and Deputy Secretary of Defense Paul Wolfowitz confer after a meeting in the White House July 1, 2003.

Page 80. Clockwise beginning upper left: President Bush, Powell, Rumsfeld, Rice.

Page 81. Left to right: White House Spokesman Scott McClellan, Wolfowitz, Attorney General John Ashcroft.

Page 82. From left: President Bush, Secretary of State Powell, National Security Advisor Rice and Secretary of Defense Rumsfeld strike different poses during a NATO meeting in Prague, November 21, 2002.

Page 83. President Bush poses with members of the Washington Ballet at a children's Christmas performance in the White House, December 8, 2003.

Page 84. From left: Emperor Hirohito, translator, President Bush, Laura Bush, translator, and Empress Michiko meet formally in Tokyo, February 19, 2002.

Page 85. President Bush shakes hands with pilot who flew him out to the carrier USS Abraham Lincoln where the president was to make a speech, May 1, 2003.

Page 86. George Bush holds a copy of Weekly World News during a light moment aboard his campaign aircraft May 3, 2000.

Page 87. President Bush and French President Jacques Chirac look to the sky as rains ended just as they arrived at Elysee Palace in Paris, May 26, 2002.

Page 88. President Bush is greeted by China's President Jiang Zemin during an economic meeting in Shanghai, October 21, 2001.

Page 89. President Bush and Laura Bush enter the Temple of the Emerald Buddha during a visit to Thailand, October 19, 2003.

Page 90. President Bush responds to reporter's questions in the White House, October 6, 2003.

Page 91. President Bush looks at Ebola cultures through a microscope while touring the National Institute of Health Vaccine Research Center February 3, 2003, in Bethesda, MD.

Page 92. President Bush loses his balance while riding a Segway personal transporter at Kennebunkport, ME, June 12, 2003.

Page 97. President Bush calls out to reporters as he walks toward Air Force One in Waco, TX, November 1, 2003. He was headed for Mississippi to support local candidates.